CHANEL

FRANÇOIS BAUDOT

ASSOULINE

1 ike a tale from *The Arabian Nights*, Chanel's life story is one of magical transformations. She had five distinct lives (five being without a doubt her lucky number), and while each one does not spring directly from the one before, they were nevertheless connected by one continuous thread which stretched from the beginning of this century to the end: style. The Chanel look was to survive all the changing dictates of fashion. Its principles were order, poise and good taste, as distinct from 'tastefulness.'

Chanel No. 1 came into the world by accident on 19 August 1883 in Saumur. Her mother died shortly after. With no identity papers to bear witness to her beginnings, the origins of this very first Chanel, Gabrielle

Chanel, remain shrouded in mystery. She attended a convent in Aubazine where she was made to wear black by the nuns. Under these echoing Cistercian vaults she plied her needle and learned the ways of silence: austerity, good manners and solitude. Aubazine, in Corrèze, was still in the Middle Ages but the twentieth century was knocking at the door.

C hanel No. 2 started out in Moulins, a garrison town, where she sang in bars known as *café-concerts* and became known as Coco. Slight and dark, with jet black eyes, a triangular feline face and an equine nose, the young girl already stood out from the other singers around her. Now she gained a name for herself – and admirers. Some of these were wealthy, some were titled, often they were both, and they wanted fun – with a different sort of woman. Coco was twenty-five years old. She had a good figure and she wanted to get out of her situation. What other option was there? She went to live with a man called Etienne Balsan in the outskirts of Paris. He was a man of the world, an anti-snob who respected her at least as much as thoroughbreds that he admired so passionately. Chanel's second incarnation was inextricably bound up with horses; the austere elegance and the almost militaristic streamlining of the riding habit made a lasting impression on her. In the saddle she learned an essential discipline: never to use force but always to remain relaxed.

Both the *haute école* and *haute couture* as practised by Chanel share this understated elegance, this valuing of discretion over ostentation. Chanel would go on to teach it to her followers. Who better than Gabrielle to observe this very masculine, very English principle, keeping company as she did then with wealthy sporting types? One of them, Boy Capel, more handsome and more brilliant than any of the others, became her lover

and, more importantly, her friend. (He died young and came to symbolize for her a passion that would remain forever unfulfilled.) Capel soon realized that the only thing the proud and beautiful Coco really loved was work – and not the kind of work she had done hitherto. What the young woman wanted was to use her hands, her head and her very definite likes and dislikes. And so it was decided: Chanel would be a milliner. It was her road to freedom.

e tienne Balsan generously offered her his ground floor bachelor flat, which Coco transformed into a studio. Her girlfriends, who were still leading the good life with their various gentleman admirers, wore her first creations, thinking they were doing her a favour. Sometimes she was mocked for her boaters decorated with just one knot of big black beads, or for her stylish schoolgirl dresses but it was a changing world and Coco was on the right track. To the women of the Belle Epoque who passed each other in their glittering splendour at Maxims, tarted up in feathers and weighed down with lace and pearls, Chanel's designs seemed somewhat unsophisticated. 'One can never be too modern,' Chanel declared in a December 1961 issue of *Jour de France*. Without truly realizing, her determination initiated a philosophy that would grow and grow.

It was now time for Chanel No. 3 to be born. Not entirely by chance the place where she was to blossom, to grow and to come into her own was one that combined sea, horses and men: Deauville on the north French coast. A few months before the First World War broke out, she opened a boutique there with 'Gabrielle Chanel' emblazoned on the awning. As well as her extremely minimal hats, the young milliner had already begun making a few discreet accessories inspired by workmen's and sailors' clothes. Her easy-fitting, flowing designs could be worn for

exercise and for sport. They were made for a kind of woman who so far only existed in the mind of their creator. Chanel preferred getting a sun-tan exercising in the fresh air and bathing in the sea, to perspiring in ostentatious dresses at balls and casinos in spa towns. She was a privileged partner of men, rubbing shoulders with them as an equal. Soon she was to prove that she could surpass them.

Slight, androgynous and sun-tanned, Coco would plunder the wardrobe of the men for ideas. She wore a college girl's gabardine raincoat or a fisherman's outfit in white twill, dark wool and chiné jersey. Her skirts were short, so that she could the more quickly run up the ladder of fashion. Nobody realized that she was inventing the style of Chanel, the elegance of Chanel, the age of Chanel. Picasso had just painted *Les Demoiselles d'Avignon*. Stravinsky had composed *The Rite of Spring*. Diaghilev was starting his Ballets Russes. Who would have guessed that one day all of them would be her friends? Of those who smiled condescendingly at this slim and unconventional woman, how many would have foreseen that the ostentatious reticence, her penchant for minimalism and the gilded poverty that she was introducing, would become the subtlest, most powerful kind of élitism which would determine what women wore and how they behaved for the next fifty years?

meanwhile the privileged classes were starting to grumble. Income tax was beginning to bite. Women had become emancipated. During the war they had replaced men in the factories, and to stop their plaits getting caught in the machinery, they cut their hair short. Society itself was increasingly industrial; speed, not sport, was the new leisure activity. Racing cars flashed by, aeroplanes soared, steamers cut through the waves. And the epitome of this 'new man in a hurry' was Boy Capel. The love, the life

and the financial backer of the young milliner was the very antithesis of the old-style idle Parisian gentleman strolling along the boulevards and the banks of the Seine. Brought up in England, he had made his fortune selling coal for the railways to wartime France. He was to be killed at the wheel of his sportscar.

Just as the oyster's irritation secretes the pearl, so Coco came out of this ordeal all the stronger, wrenching open her shell to face her solitude once more. Even in its depths, she was polishing up her best weapons ready for the battle ahead. This time the third Chanel got it right. She carefully blotted out her past as a poor orphan and the demi-mondaine that she almost became, discarding (as she did in her biography) an entire decade from her life. In her own creations, she even looked ten years younger.

When she moved to rue Cambon in Paris in 1910, the world was ready for her. Knowing she was the right person at the right time, she opened a shop at number 21. Crowds flocked to it, and in a matter of just a few years, she took over numbers 27, 29 and 31 of the same street; her original fashion house there still carries her name. After the war, haute couture was to become a major industry, catering for an affluent bourgeois clientele just as expensive ready-to-wear clothes shops do today. Chanel became the object of bitter rivalries, internecine feuding and high financial stakes. The young woman was ready for them and would win.

●

In her ivory tower she owned an apartment where she never slept. Above it was the workshop which she rarely left. On the beige door can still be read the imperious, timeless, anonymous 'Mademoiselle Private.' Written in black letters, it signalled the end of a long journey.

Withdrawing herself (and therefore making herself all the more sought after), Chanel No. 3 gave up all hope of happiness again, and resigned herself to a life of plots and business deals. Yet shy and unsure of her powers as she was, she enchanted Paris during *les années folles*. Who would have predicted the impact that her temperament and her creations were about to have? Coco still knew only a handful of the polo playing set and had everything to learn about the world on which she was already sitting in judgment.

I t was Misia Sert, a sort of *fin-de-siècle* muse, who was to help her break into the Parisian scene. First she met Jean Cocteau, Raymond Radiguet, Les Six and the *Boeuf sur le Toit* gang. Then it was Serge Lifar, Christian Bérard, José Maria Sert, Blaise Cendrars, Pierre Reverdy, Salvador Dalí, the Bourdets, the Beaumonts, the Jouhandeaus … All those who had swept away the past with the creation of modern art were to meet the woman who had buried Worth, outshone Paquin and killed off the great Paul Poiret; she who had freed women's bodies from tight-lacing corsets and padding, restoring them to their natural state; who was responsible for Egyptian dancers, Ancient Greek shepherdesses and wild children roaming the countryside in schoolgirl smocks. The two women sized each other up, appraised each other and showed, each in her own way, how it was possible to be feminine while turning one's back on class. Thousands of women now began to realize that 'poor chic' could be the answer to social snobbery. The Chanel look, with its lines reduced to their simplest expression, shows that *how* clothes are worn is much more important than *what* is worn; that a good line is worth more than a pretty face; that well-dressed is not the same as dressy, and that the acme of social cachet

was to be proletarian. Youth, according to Chanel, should not have to declare itself, it should be obvious all the time: in sitting down, getting into a car, walking down the street, stretching out a leg or raising an arm. It was about ideals rather than outfits, concepts rather then costumes. What has made her style last is the fact that it is functional, which is in keeping with the pace of contemporary life.

But in addition to this, it was the audacity with which she used herself as the model for her own creations that allowed Chanel from the thirties onwards to impose her ideas on fashion. 'I invented sportswear for myself,' as she would later say. 'I set the fashion for the very reason that I was the first twentieth-century woman.' Before Chanel, the fashion designer was merely a supplier. Chanel raised herself to the rank of her clients, whom she would always refuse to meet. What she did do was to enlist some of them into her fashion house and her business. Princesses displayed her dresses and sold her jewelry.

' ●

I am a lie that tells the truth'; that paradox of Jean Cocteau could have been embossed on the cover of Coco Chanel's life story. Under the influence of the men in her life, she enriched a style which was essentially her own. The exiled Grand Duke Dmitri of Russia, a relation of Tsar Nicholas II, introduced Chanel, the daughter of a humble tradesman from the Auvergne, to the splendour of Byzantine imperial icons and baroque jewelry, which inspired her. She then scattered sparkling imitations over her little usherette dresses, while building up a personal collection of authentic jewels. For example, she audaciously wore pearls with a tweed jacket while riding with the Duke of Westminster. He shared her life for ten years, during which time she learned the power of great wealth and also the detachment, distance

and isolation that a great name can bring. 'Westminster is elegance itself. He never has anything new – I had to go and buy him some shoes. He has been wearing the same jackets for twenty-five years.' Today such comments seem pure Chanel. She ended her description with wry humor: 'It's just as bad being too rich as it is being too tall. In the first case, you can't find happiness and in the second, you can't find a bed.'

t owards the end of her life, such aphorisms were characteristic of Coco's wit. She had developed a taste for them while she was still young through her association with a remarkable poet, Pierre Reverdy, an innovator and precursor of the Cubists, to whom she gave lasting friendship and support. This great mystic had wit enough and to spare, and Chanel made good use of him. At odd moments, she would write maxims that her friend would correct or complete; for this he was tactfully renumerated. 'He who pays his debts gets richer,' she once said with her proletarian common sense to the Tsarina. She also spent an enormous amount of money on Paul Iribe. When she met him at the beginning of the thirties, she was at the peak of her glory. A creative yet also strangely destructive individual, Iribe was a remarkable illustrator, and a designer of furniture, jewelry and interior decorations. He collaborated with Paul Poiret, Jean Cocteau and various Hollywood film-makers, artists often more talented than himself. He was the classic type of artistic director.

Europe meanwhile was in crisis and heading towards war, and Coco was seriously thinking of marrying Paul Iribe. She was fifty years old but looked thirty. Her picture would be taken by the greatest fashion photographers in the world including Man Ray, Horst P. Horst and George Hoyningen-Huene.

In her the role of the model was crystallizing into that of role model – a model with personality, a model who could talk. This concept was realized remarkably enough in the eighties when Inès de la Fressange, 'the face of Chanel', would launch the reign of the supermodel.

What gave Chanel her image was the logo (not as yet called this): the letters, the typography, the gold, the black and the white; the use of repetition, which anticipated Pop Art; the perfecting of a grammar and a vocabulary which belonged to her alone; the expression of her masculine side and her intense femininity; her brown, angular, sun-tanned figure, and her lack of sentimentality. From Mademoiselle through Gabrielle to Coco, then finally becoming Chanel, she had pulled herself up to join the highest ranks of fashion personalities. More than that, she was one of the chosen few who shaped an entire era when everything was being reinvented.

●

In 1938 Picasso painted *Guernica*. Michel Leiris wrote prophetically regarding this painting: 'All that we love is going to die.' Paul Iribe had already suffered a fatal heart attack after a game of tennis at Chanel's villa in the south of France. Once again she was left to her splendid isolation. Rich, famous and at times wearied by devastating setbacks, she closed her fashion house in 1939. A page had been turned, and the story could have ended there.

'Many of Chanel's private dicta have entered into the unspoken rules that still govern fashion,' wrote Cecil Beaton, an expert on the matter, in *The Glass of Fashion*, a treatise on good manners and thus also on good dress sense in the twentieth century. Writing at the beginning of the fifties, the photographer continued: 'After the war Chanel retired from the active world of fashion,' and he concludes with great foresight: 'Though

Chanel herself echoed the theory that fashions are never revived, it is a tribute to her rare and remarkable practicality, and an anomaly in the annals of recorded fashion, that few of her innovations became dated. With each season she watched, like Nature's seeds, her past creativity flowering anew, barely hidden behind the vague alterations of less talented designers.' He chose his words carefully.

●

i t was the success of Christian Dior that hit her most hard. She who had presided over the revolution of fashion now watched from her exile the restoration of costume. Rustling petticoats, draped fabrics, waspwaists, hems down to the ankles ... Dior's 'New Look' in 1947 was the antithesis of the Chanel style. Now it was the eternal woman, a queen, a star, a pin-up, celebrating the return of prosperity in a dazzling display. After the Liberation, no one had any use for the 'little undernourished telegraph girls' of Coco's designs. The ideal woman of the Fourth Republic was definitely well-covered.

Chanel waited and kept quiet, letting men such as Dior, Cristobal Balenciaga, Pierre Balmain and Jacques Fath believe that once again they could be the ones in control of women's destinies. But surely women would not have forgotten the freedom Coco had promised them? The New Look came and went. In 1953 the designer, coiled up on her couch like a cobra preparing to strike, felt that Chanel's time had come round again.

Chanel No. 4 made her comeback on 5 February 1954 but to an icy reception. She was over seventy years old. A failure would not just be a terrible disappointment, it would also jeopardize the one remaining asset from her empire: her perfumes. To try her luck a second time at an age when most people have long been retired, required a great deal of self-assurance. But since her youth, Gabrielle Chanel had defiantly cheated

time. She clung to her belief that: 'I set the fashion for a quarter of a century because I was of my time and it is important to do things exactly at the right moment. Fashion changes but style remains.' She proved it immediately. The first collection of her second career was more than a comeback, it was a veritable rebirth. True, the French press derided her and faithful supporters were thin on the ground; Dior was still the unanimous favourite. But slowly and surely, the Chanel machinery started up once again.

'What's new? Chanel,' read the cover of *Elle* magazine. Its founder, Hélène Lazareff, who had come back from the United States in 1945 full of new ideas for women, would from now on offer unwavering support for the Chanel look in the pages of her magazine. The fashions of this famous little dressmaker now took to the streets. No imitator could ever come close to the original or to her phoenix-like ability to renew herself. This is still true nearly forty years later. The Americans were quicker than the French to realize that a real Chanel phenomenon was underway; they applauded and bought into it. From now on, they too would have their say in the fashion world. A year after her legendary comeback, the great Coco, now restored to her old reputation, reconquered the rest of her empire. Soft jackets with no interlining, wonderfully managed sleeves, silk blouses, gold chains, wrap-over skirts, quilted shoulder bags leaving the hands free, flat shoes with a bar across and a black toe to shorten the foot, jewel-like buttons on jackets and false buttons cascading down the front of the garment … plus a thousand other original ideas which have today been eagerly adopted by the general public. The 'Chanel Look,' as it was christened by the English-speaking press, swept across both sides of the Atlantic. It was a landslide victory.

The image the public had of Chanel was of her sitting on the steps of her couture house, concealed behind a forest of gold, Coromandel lacquer work and rock crystals. She was the high priestess of classicism whose judgments could not be questioned and who, right to the end, continued perfecting her profile and her style, spinning, weaving and snipping like the three Fates rolled into one. This fearsome yet magnetic image is the one that has lasted; the dressmaking queen bee who, since her return, lived at the Ritz on the other side of the rue Cambon. Then, one Sunday in 1971, she died. That day her hive closed down. But this was not the last of her: the memory of the woman who had rejected her own past was now to enjoy a considerable afterlife.

C oco, a key-figure of her time who had fashioned herself as well as her own style, lived on in Chanel. It is a family name which, to the detriment of the House of Chanel, and in fact illegally, has become a common noun. Six letters to sum up a legend of the twentieth century, the fifth incarnation being her most emblematic perfume.

Beyond a doubt, Chanel No. 5 leaves the most famous trail of scent in the world. When it was launched in 1921 from an original creation by the perfumer Ernest Beaux, it was totally novel. In its small stoppered bottle with its sharp lines, embossed with its reference number, this abstract fragrance was created from a secret cocktail of over eighty ingredients. In one day, Chanel had supplanted and killed off traditional perfume which instantly became old-fashioned. Before her, perfume was not the business of the fashion designer. Cut-glass bottles displayed names like 'Evening Revery,' 'Pink Clover,' 'Spray of Happiness' and other romantic names with easily identifiable flower oils. Chanel No. 5 smelled like none of these scents, nor like anything other than itself.

It was sufficient to prolong Chanel's name, couture house and work well beyond her own life span.

t he fifth life of Chanel is as astonishing as the others, although much harder to tell, since it is an ongoing story. It continues with each new season and each carefully developed collection, through each new perfume and beauty product created by Chanel and stamped with the logo known the world over. After Gabrielle Chanel's death, her fashion house, her salons and her studio were dormant for a decade. This was a necessary time of mourning during which her entire empire turned in on itself and looked back to its founder to reflect on and negotiate her return to the forefront of fashion. Once again, her empire was calm, resolute and implacable.

Leaving other fashions to come and go, the Chanel look was relaunched under the leadership of Karl Lagerfeld, reconquering the magazine pages of the early eighties. To the rules and regulations of Chanel that he knew so well, the new fashion director added a slogan that he had borrowed from Groethe: 'Make a better future by developing elements from the past.'

While so many couture houses died off, the name of Chanel still figures among those on the cutting edge of contemporary fashion. In fact, Karl Lagerfeld is one of the few designers who can stand up to the invincible power of the ready-to-wear fashions from Milan. Today, fashion is no longer the exclusive privilege of Paris, but an international affair, given instant media coverage to all four corners of the globe. Upsetting Chanel's principles, juggling sometimes outrageously with her laws, practising like no one else in fashion design the art of not pleasing everyone (apart from perhaps Chanel herself), Karl Lagerfeld still knew how to introduce into each of his fashion shows for Chanel since 1983

numerous updated versions of designs formerly created by Coco. The public, however, is still able to spot a pure Chanel creation in spite of the changes, whether in Lagerfeld's haute couture or in his ready-to-wear designs. The company, now acknowledged as one of the outstanding luxury brands, is unanimously acclaimed as a model of continuity. Continuity in fashion, but also in perfumes, and as a name that shines among the elite circle of place Vendôme jewelers.

Again driven by the same desire for continuity in excellence, this doyenne of couture houses recently confirmed its loyalty to those whom Karl Lagerfeld calls 'our satellites' when it acquired Desrues (accessories), Lemarié (feathers), Lesage (embroidery), Massaro (footwear) and Michel (hats), all elite suppliers of Parisian luxury. Excellence and quality clearly are, as they have always been, the watchwords at Chanel. Gabrielle Chanel herself, a striking woman, would not have disapproved. Indeed, she was the first to understand that simplicity, when sumptuous, was the ultimate refuge of singular personalities.

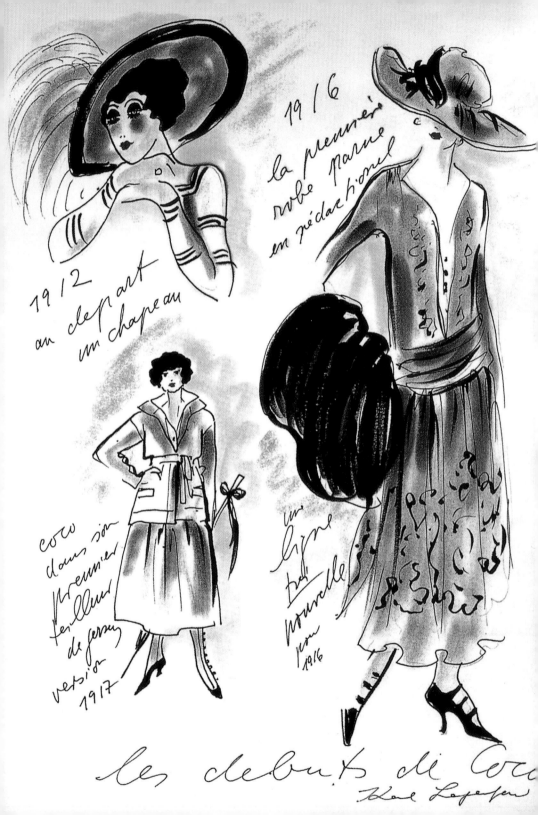

1912
au départ
un chapeau

1916
la première
robe parue
en rédactionel

coco
dans son
premier
tailleur
de jersey
version
1917

un ligne
très
nouvelle
pour
1916

les débuts de coco
Karl Lagerfeld

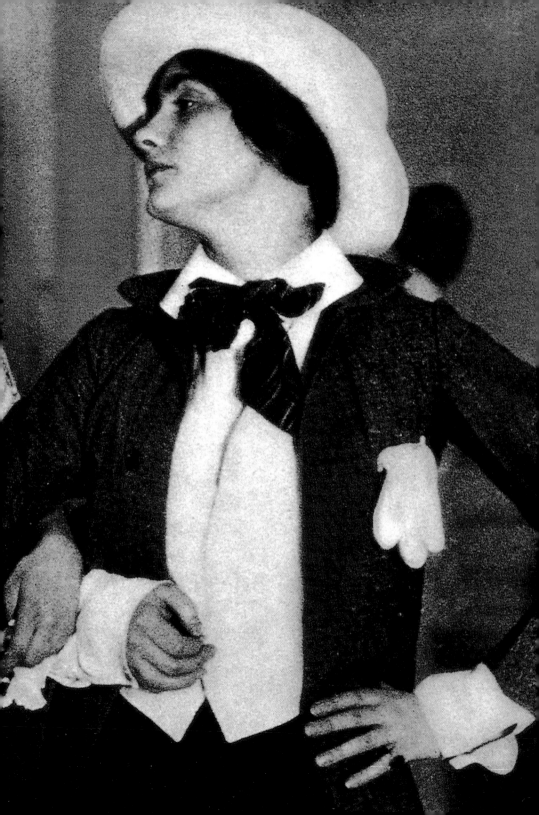

Coco dans ses robes à succès

petite robe de 1919

la petite robe Ford 25

tailleur Chanel version 1929

deux modèles de la fameuse collection "noire"

Deauville ou Biarritz coco for ev...

on l'appella alors "la reine du beige"

Les Années 20

Karl Lagerfeld

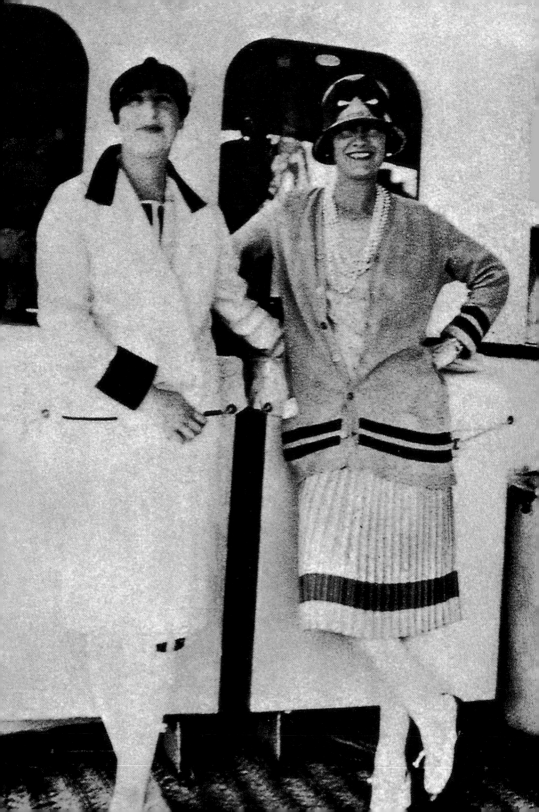

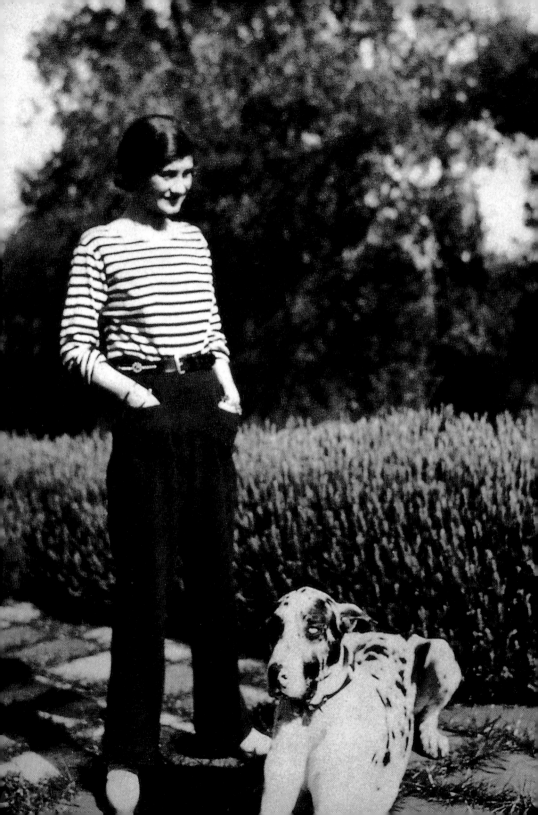

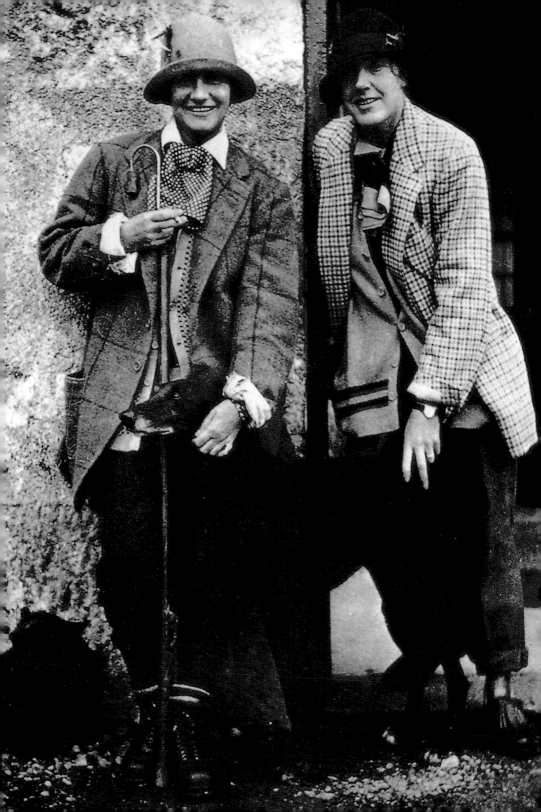

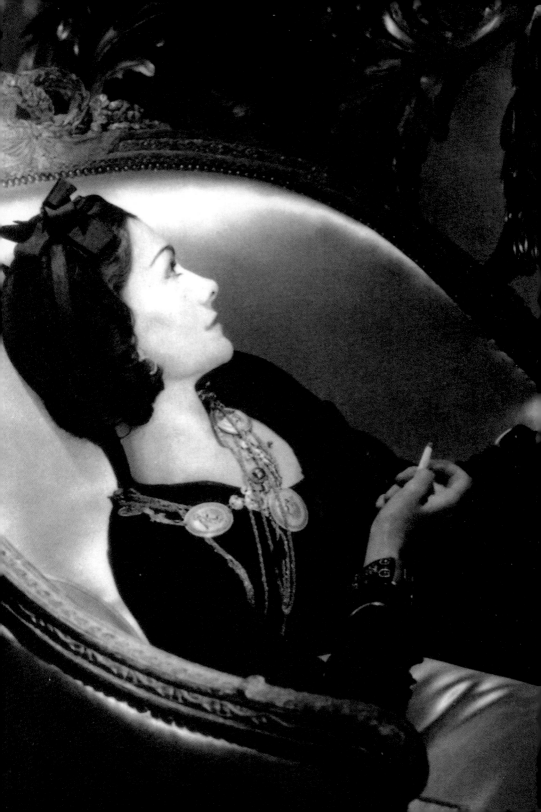

les robes du soir fauraient sa gloire alors

le camellia fait son apparition sous forme de bijoux

robe de dentelles 1938

Coco dans une de ses célèbres robes "gitane" de 1939

1935 robe sac il est en core pochette

le petit Chanel 1938 plus ceintre et épaules moins larges que 15 ans après

à la fin des années 30 le look "Coco" est en place

Les Années 30

Karl Lagerfeld 91

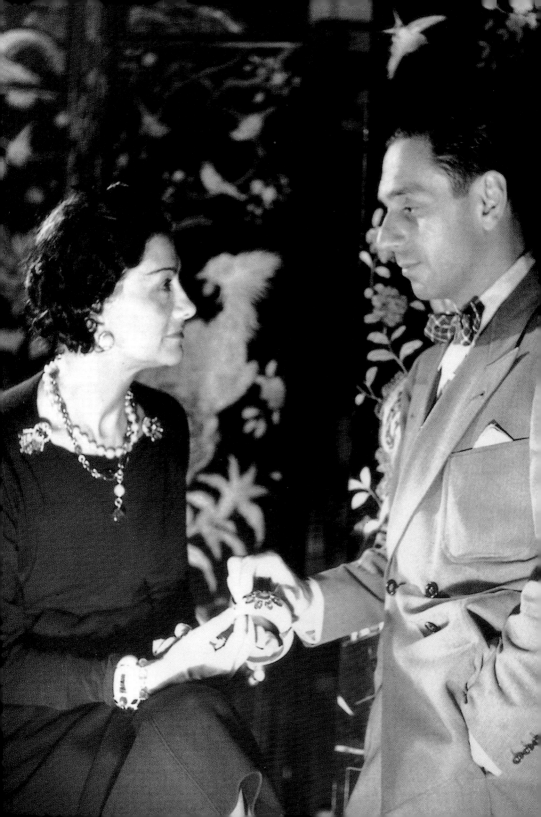

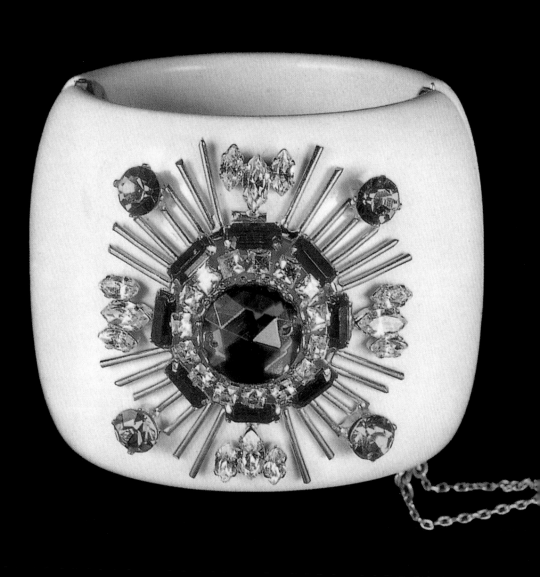

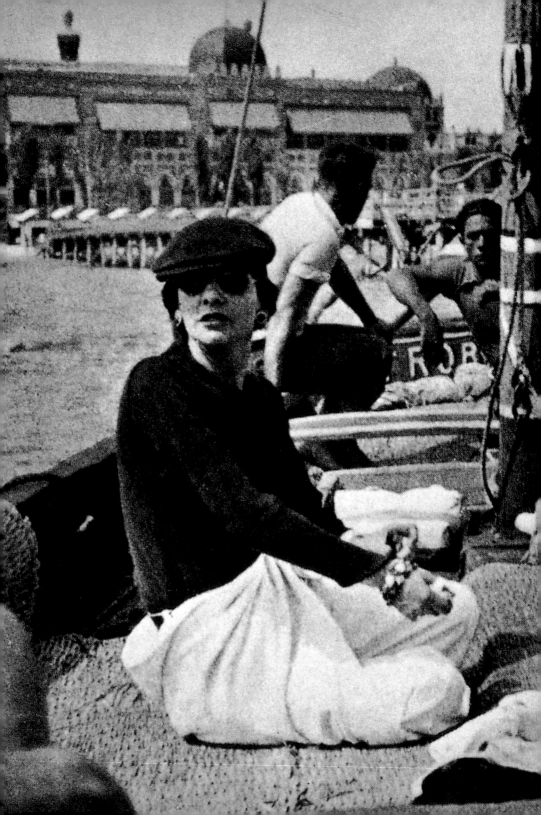

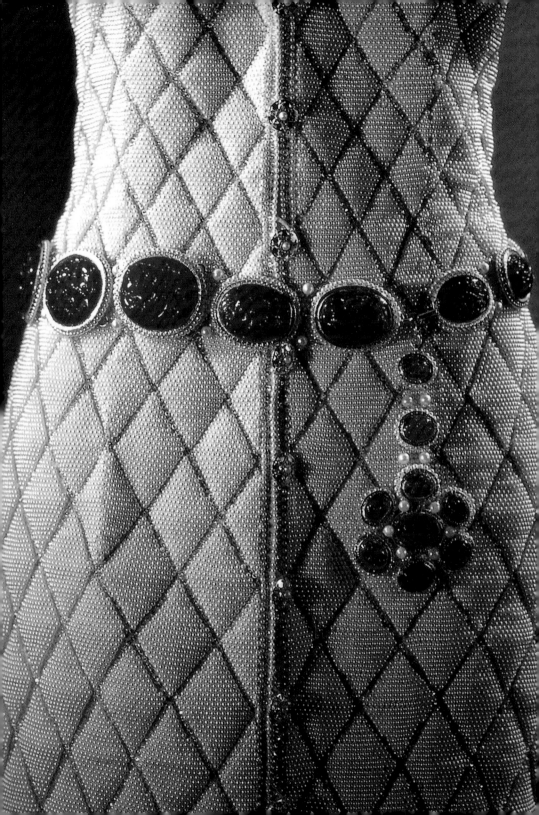

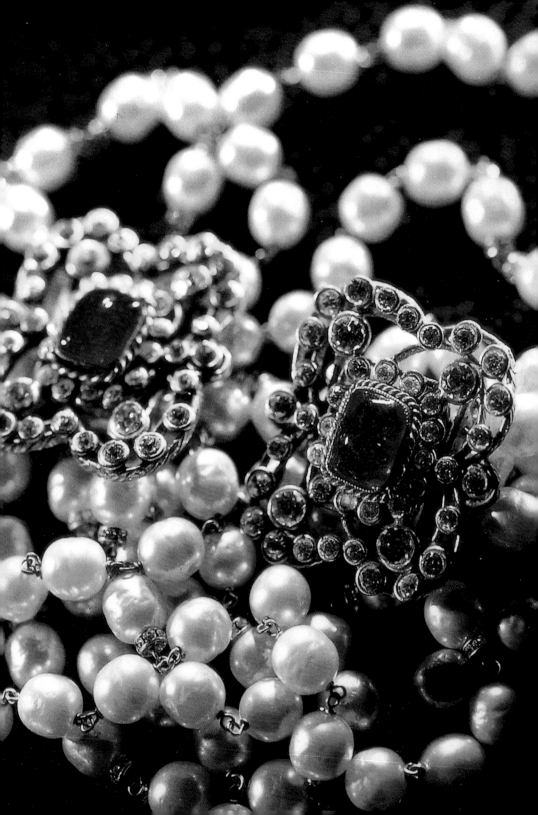

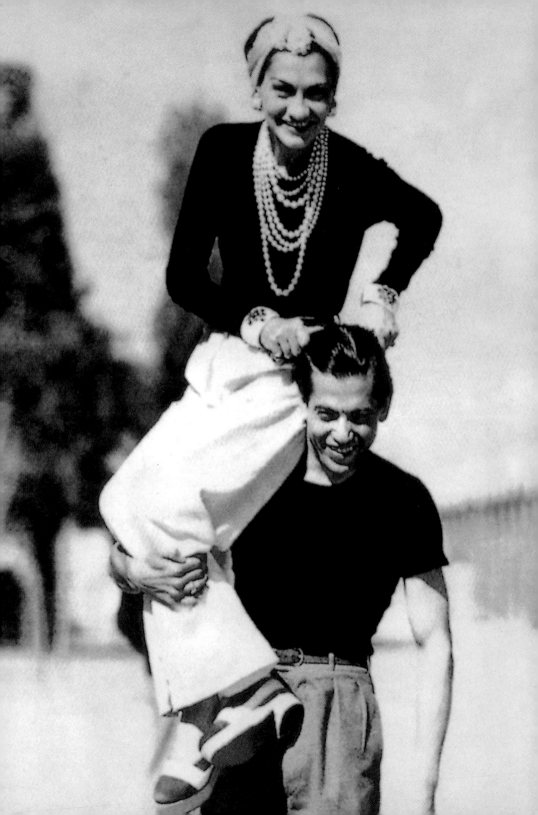

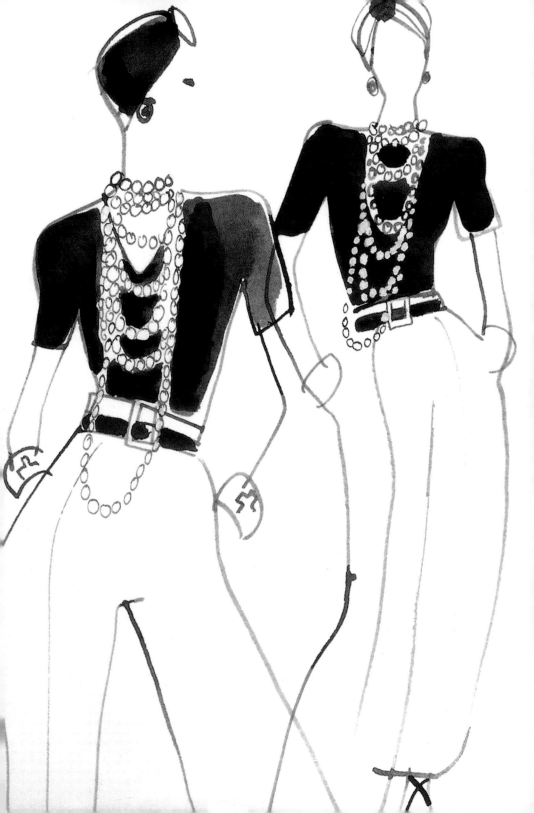

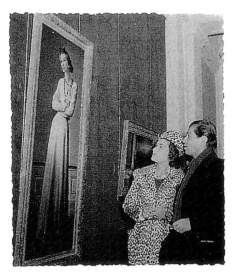

Devant son portrait par
Cassandre avec Serge Lifar

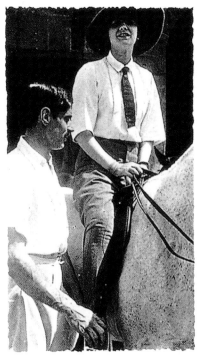

Avec Boy Capel

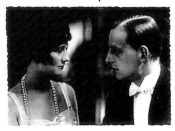

Avec le Grand Duc
Dimitri de Russie

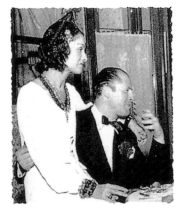

Avec le Prince
de Faucigny-Lucinge

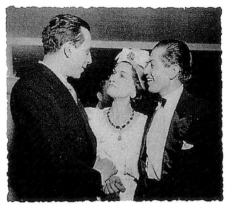

Avec l'acteur Louis
Jouvet et Serge Lifar

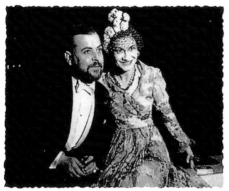

Avec Christian Bérard

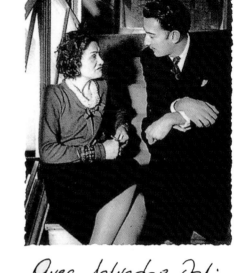

Avec Salvador Dali

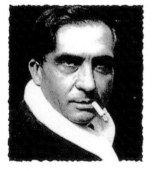

de poète
Pierre Reverdy

Paul Iribe

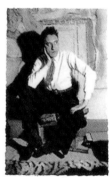

Jean Cocteau
en 1934

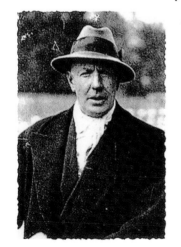

Le Duc
de Westminster

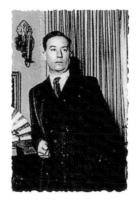

Paul Morand

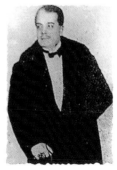

Serge
de Diaghilev

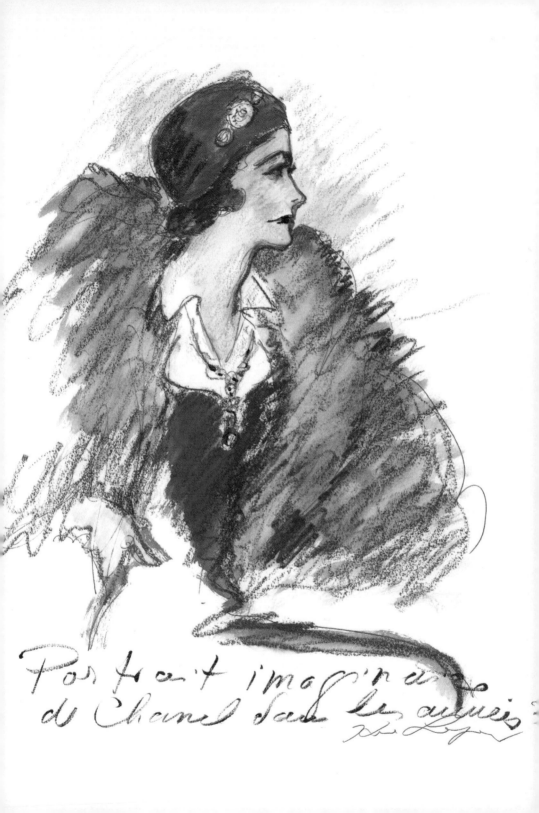

Portrait imaginaire
de Chanel dans les années

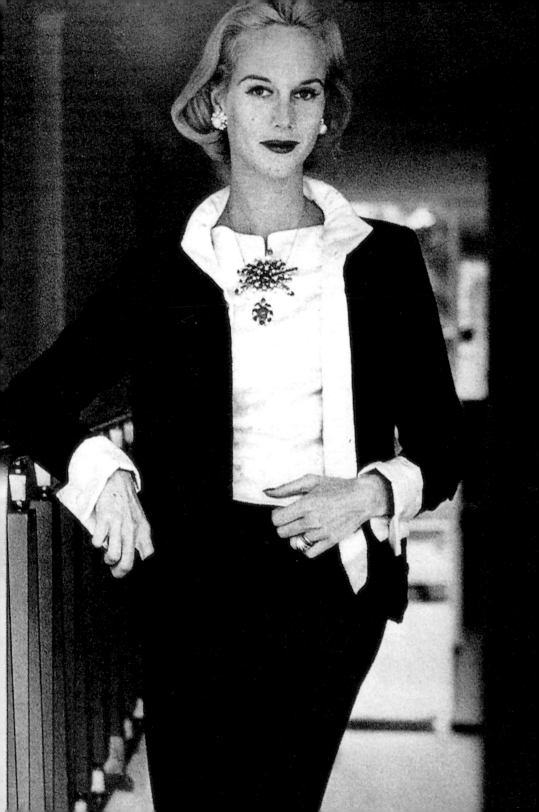

Le Triomphe de Coco

coco sourit... elle a bientôt 80 ans!

le sac
les bijoux
la chaussure
le camélia
les boutons
les chaînes
toi es!!
là!!

La "dame" des années 50 devient une femme moderne

une mode resolument moderne basée sur une idée du passé.

La Fin des Années 50
Début des Années 60

Karl Lagerfeld

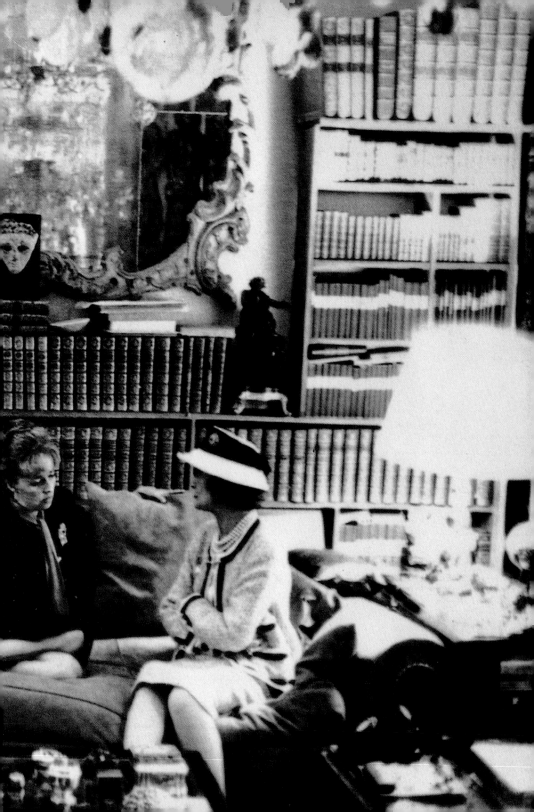

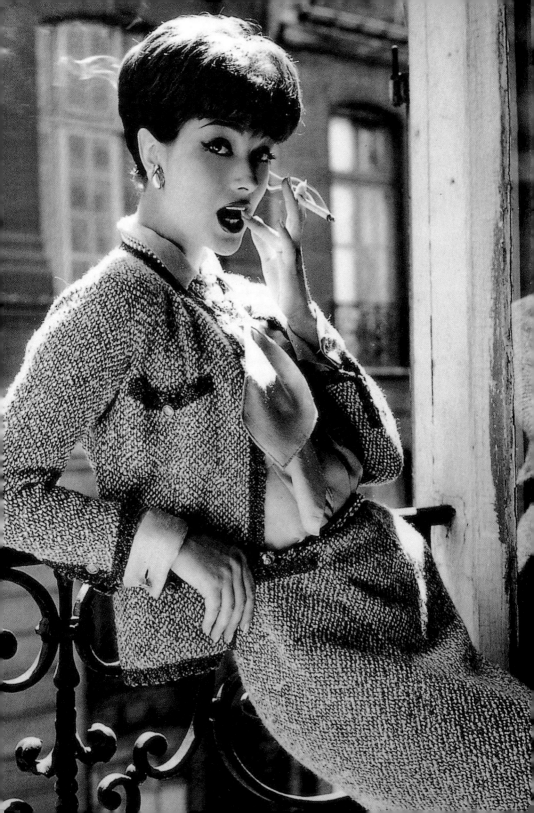

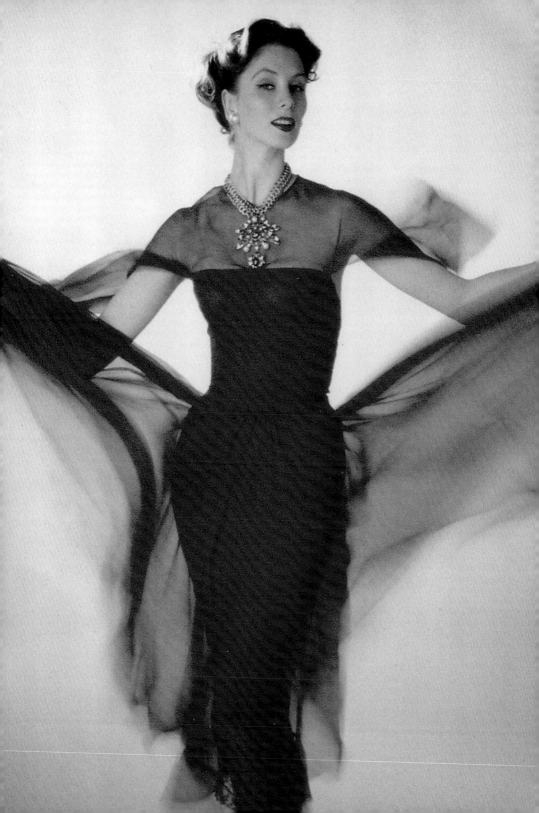

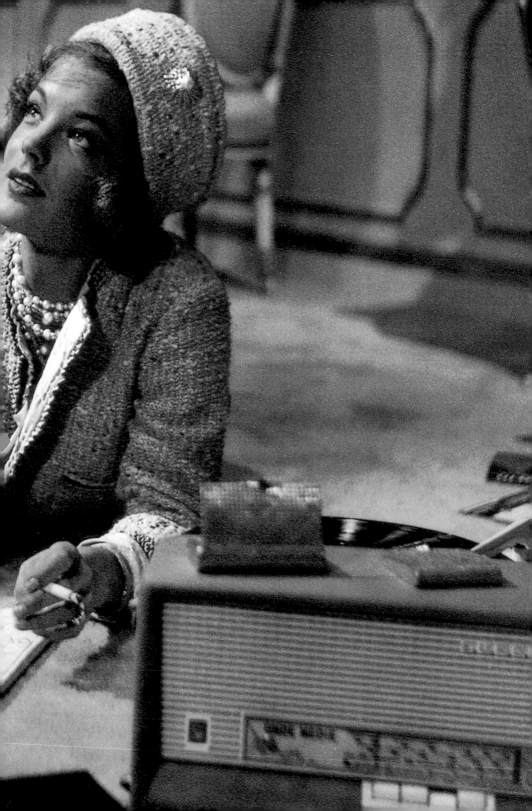

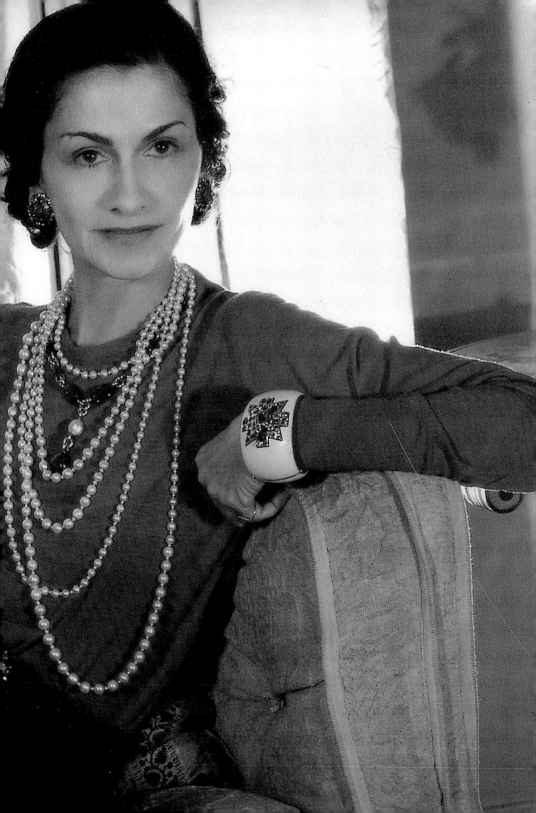

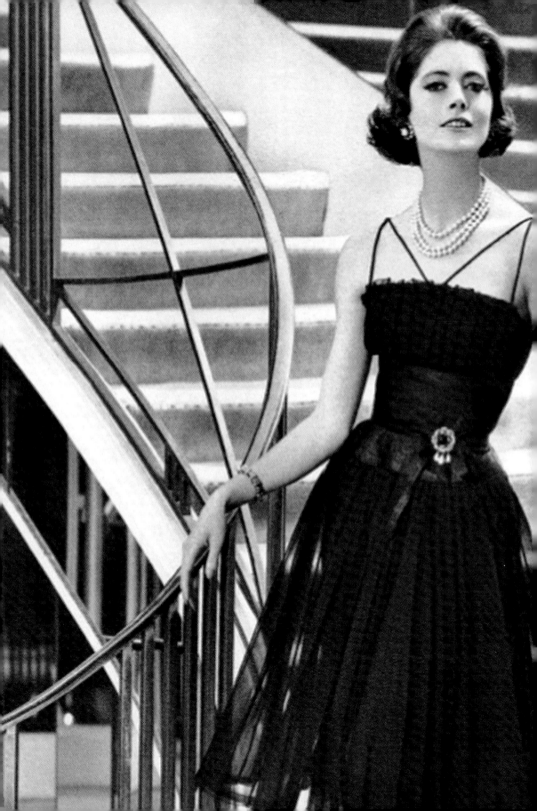

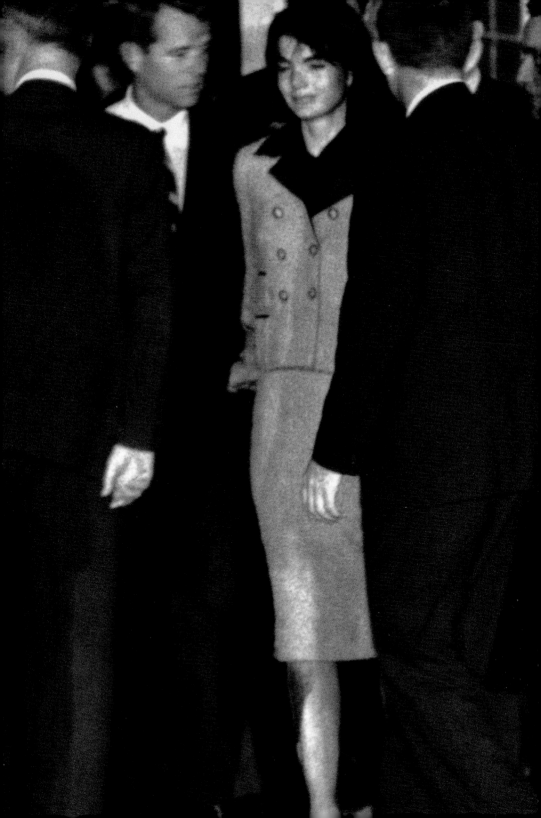

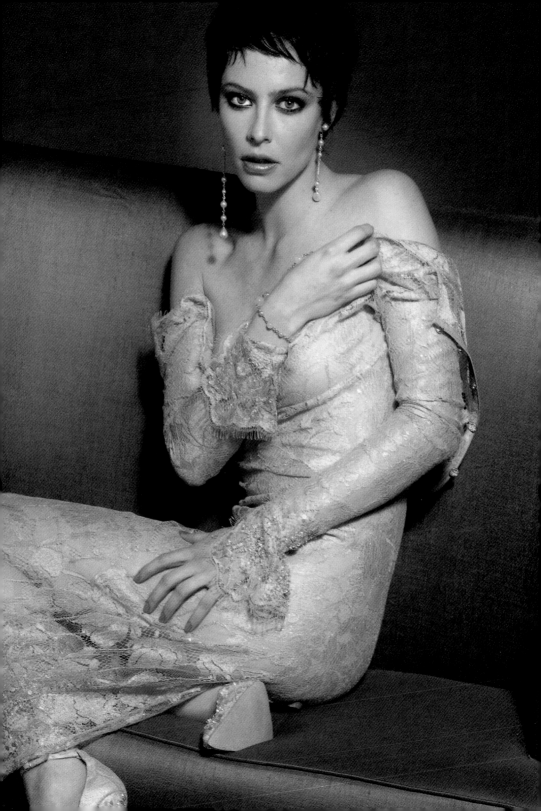

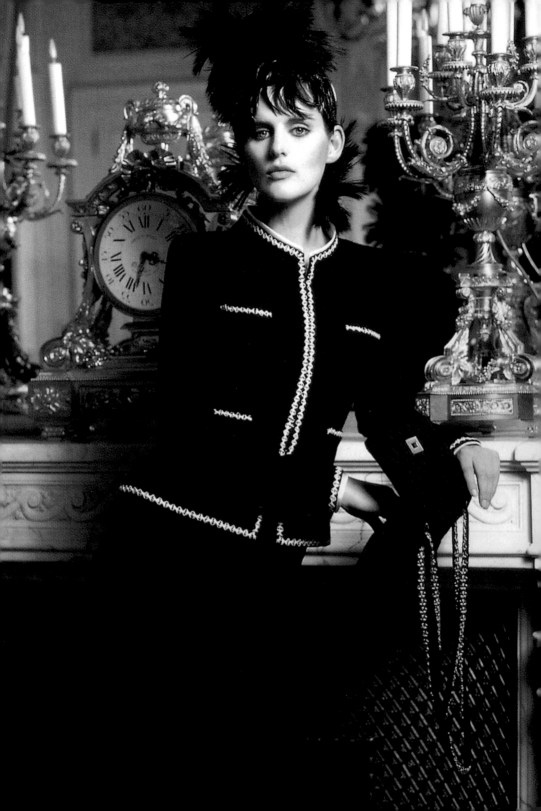

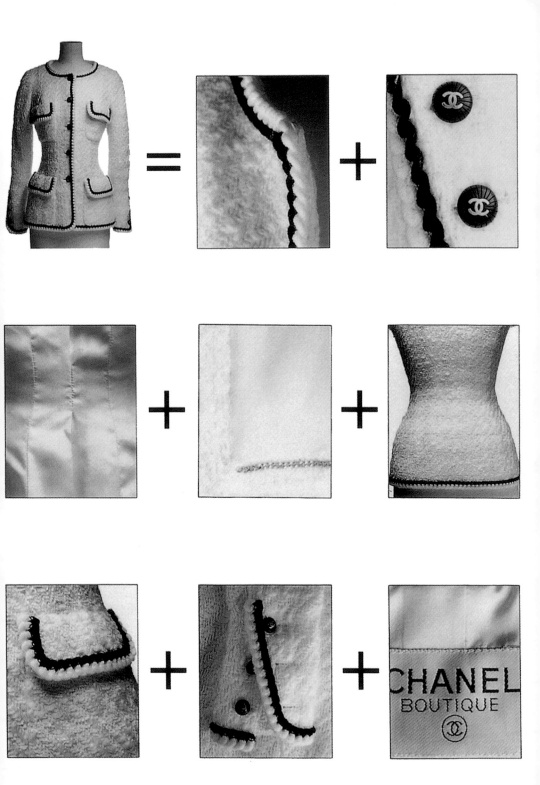

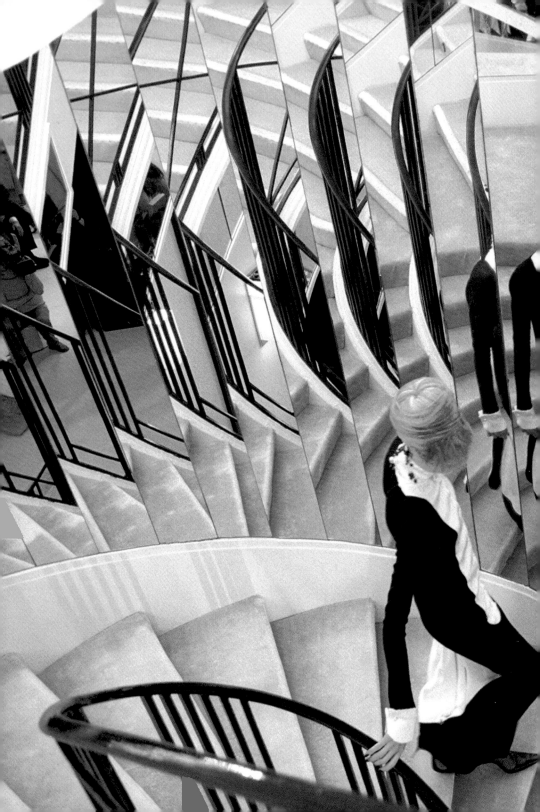

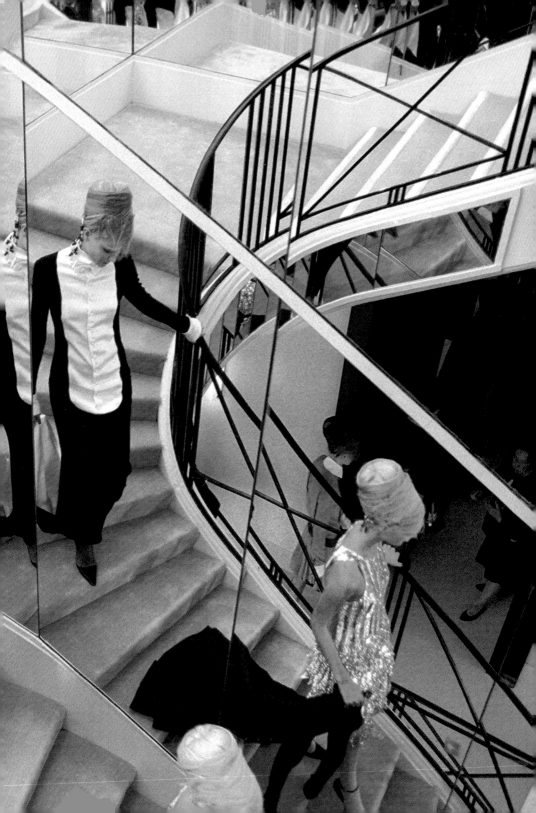

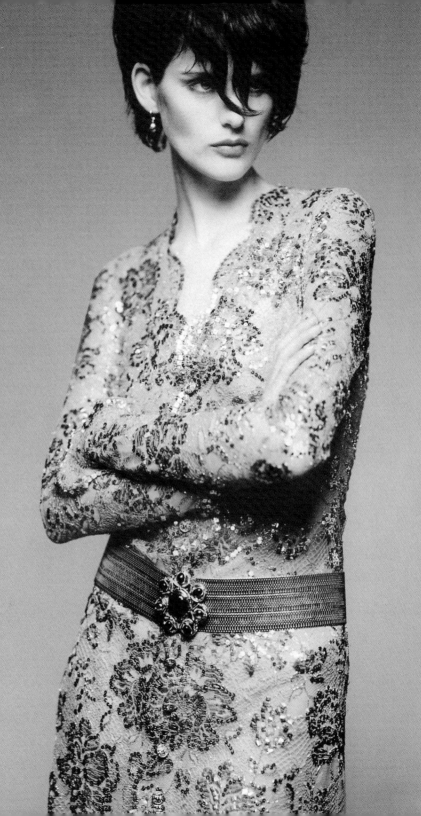

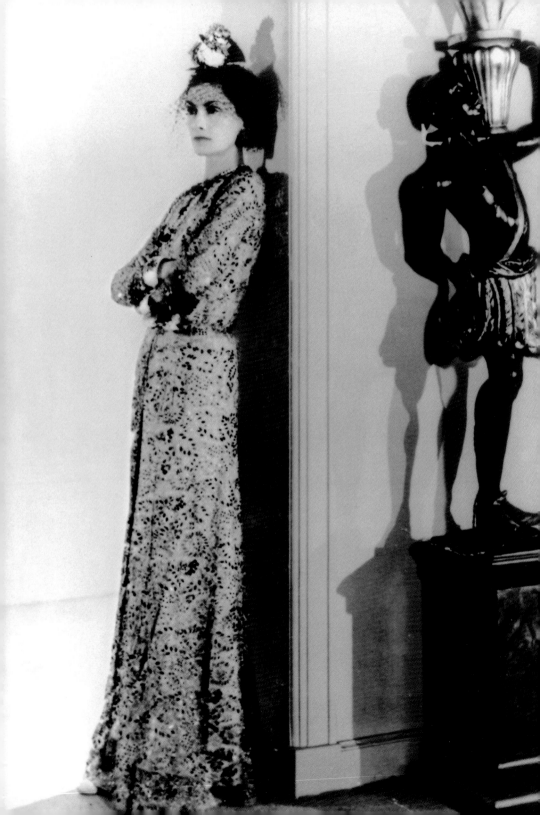

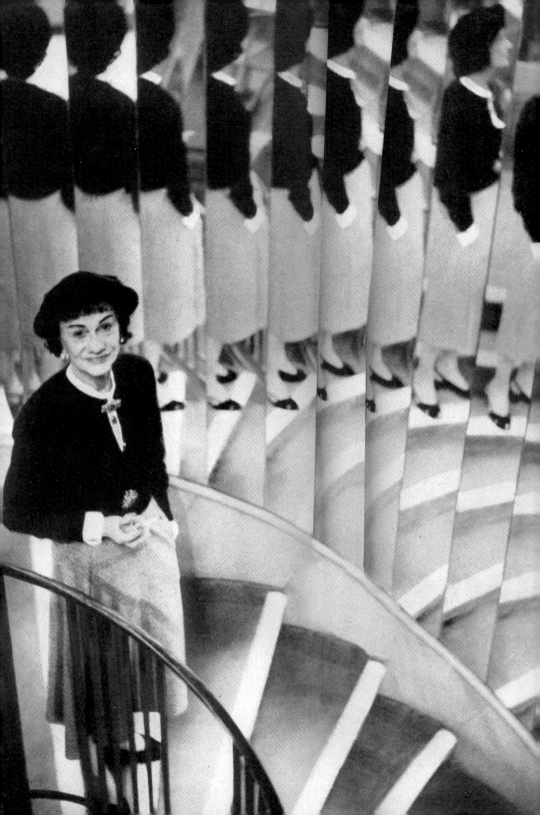

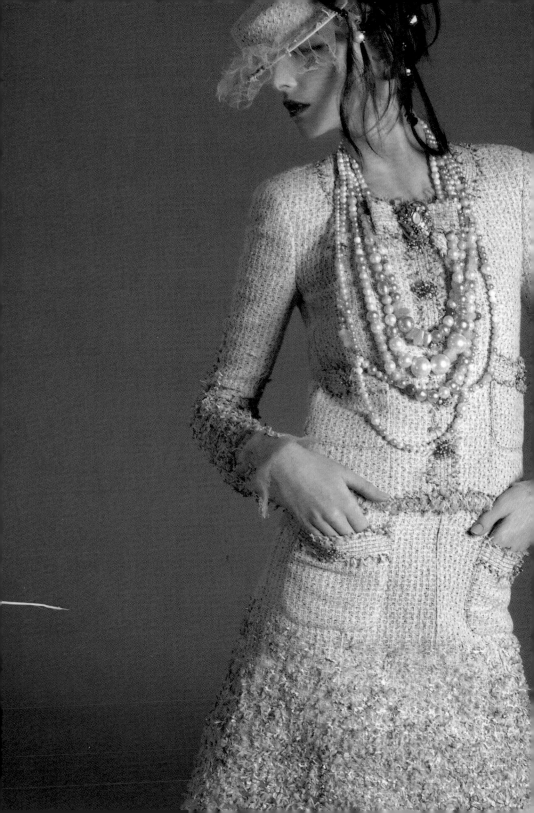

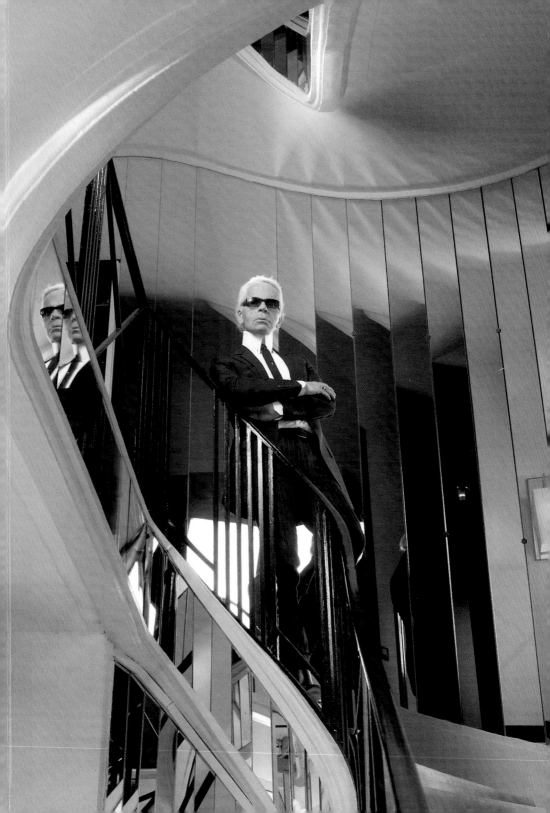